Buckingham Palace

I chose this view of Buckingham Palace because I liked the way the contrasting violet and red flowers along with the spring grass add bright colour and interest to the foreground. Most of the fine detail in both the statues and the palace itself are hinted at rather than rendered in too much detail. It is important that the palace is painted in muted, fairly pale greys, to emphasize its position in the middle distance rather than the foreground.

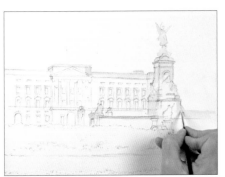

1 Use masking fluid to mask off the top edge of the palace, the statue and the whole monument and fountain.

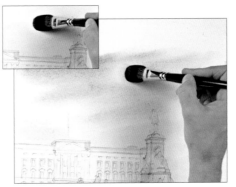

2 Wet the sky area with the squirrel mop and clean water. Apply a wash of cool cerulean blue at the bottom of the sky, then quickly paint a warmer mix of cobalt blue and ultramarine higher up.

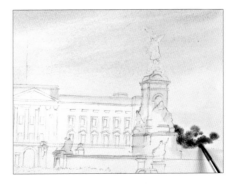

3 Still working wet into wet, use the no. 8 brush and a mix of ultramarine and aureolin to float in distant tree shapes. Allow to dry.

4 Rub off the masking fluid at the top of the palace with your finger. Paint the palace with Naples yellow and rose madder on the no. 12 brush, then while wet, float in raw sienna and burnt sienna. Allow to dry.

5 Mix a shadow colour from cerulean blue and rose madder, then paint it around the top of the building with the no. 1 brush. Soften the bottom of the line with clean water.

6 Paint the portico with the same mix and the no. 4 brush. Add light red to the mix to make grey and paint more architectural detail with the no. 1 brush. Paint detail in the portico with a stronger mix. Allow to dry.

7 Paint a thin glaze of cerulean blue over the top area of the palace and allow to dry. Add more detail with the no. 1 brush and the grey mix. Then take the 5mm (³/₁₆in) flat brush and a mix of cerulean blue and light red and paint windows with vertical strokes.

8 Mix a darker version of the same grey and use the no. 1 brush to recess the windows by adding a line along the top and the left-hand side of each one.

9 Paint more shadow along the top of the palace with the no. 8 brush and cerulean blue with rose madder, then wash this down the centre of the palace in three blocks between the pillars.

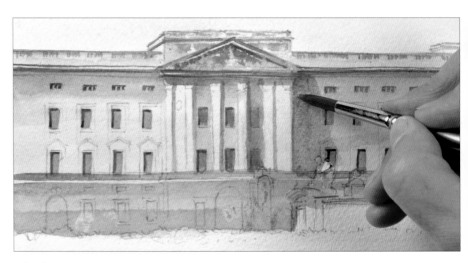

10 Add more shadow with the same brush and mix at the bottom of the building, then soften this in with a clean, damp brush. Paint in raw sienna and burnt sienna at the bottom to create reflected light, wet into wet.

11 Paint shadows on the palace with cerulean blue and rose madder. Use the no. 1 brush for smaller shadows and the no. 8 for larger ones. Note that the light is coming from the left-hand side.

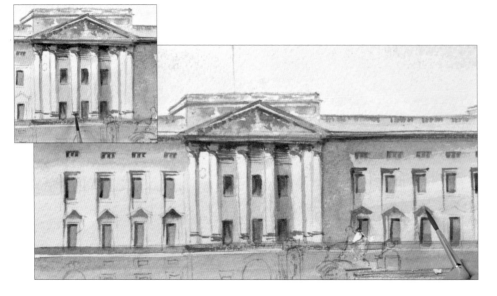

12 Build up detail in the centre of the palace with the no. 1 brush and cerulean blue, rose madder and light red. Then add detail to the window surrounds. The lower windows have a triangular 'gable' – suggest these with the same grey mix, then soften the bottom of them with a clean, damp brush.

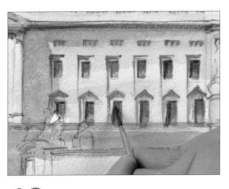

13 Darken the top parts of the windows with a mix of cerulean blue and light red.

14 Mix more of the darker grey from cerulean blue, rose madder and light red. Make a row of vertical marks to suggest the balustrade, add more darks in the central windows. Run the grey down the right-hand sides of the columns, then soften it on the left to make them cylindrical.

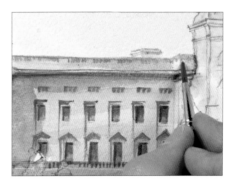

15 Add more shadow to the top of the palace using cerulean blue and rose madder on the no. 4 brush. Leave the edge facing the light.

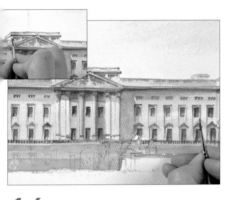

16 Sharpen up the detail in the centre of the palace with the no. 1 brush and a grey mix of cerulean blue, rose madder and light red. Add more vertical lines beside the windows.

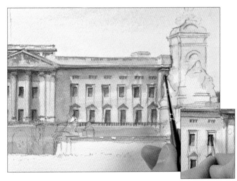

17 Make the darkest grey mix yet from cobalt blue and light red, and sharpen up the painting by adding dark details such as shadows and window darks.

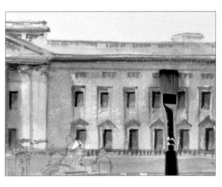

18 Use the 10mm (3/8in) flat brush with cerulean blue and rose madder to add texture to the walls by dragging the brush down, fairly dry.

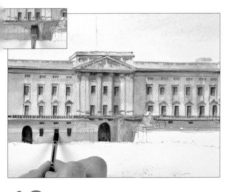

19 Use the same brush and mix to paint shadow at the bottom of the palace. Paint the arches with cobalt blue and light red on the no. 4 brush, then change to the 5mm (3/16in) flat to paint windows and other rectangular marks.

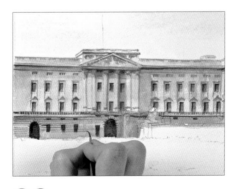

20 Use the no. 1 brush and the same mix to paint the radiating lines around the arches and the horizontal lines right across the base of the palace. Paint these long lines rapidly and freely. Allow to dry.

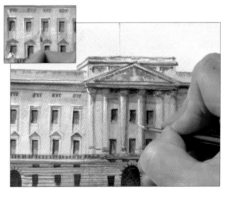

21 Mix white gouache with a little raw sienna and burnt sienna and paint highlights around the windows and on the columns.

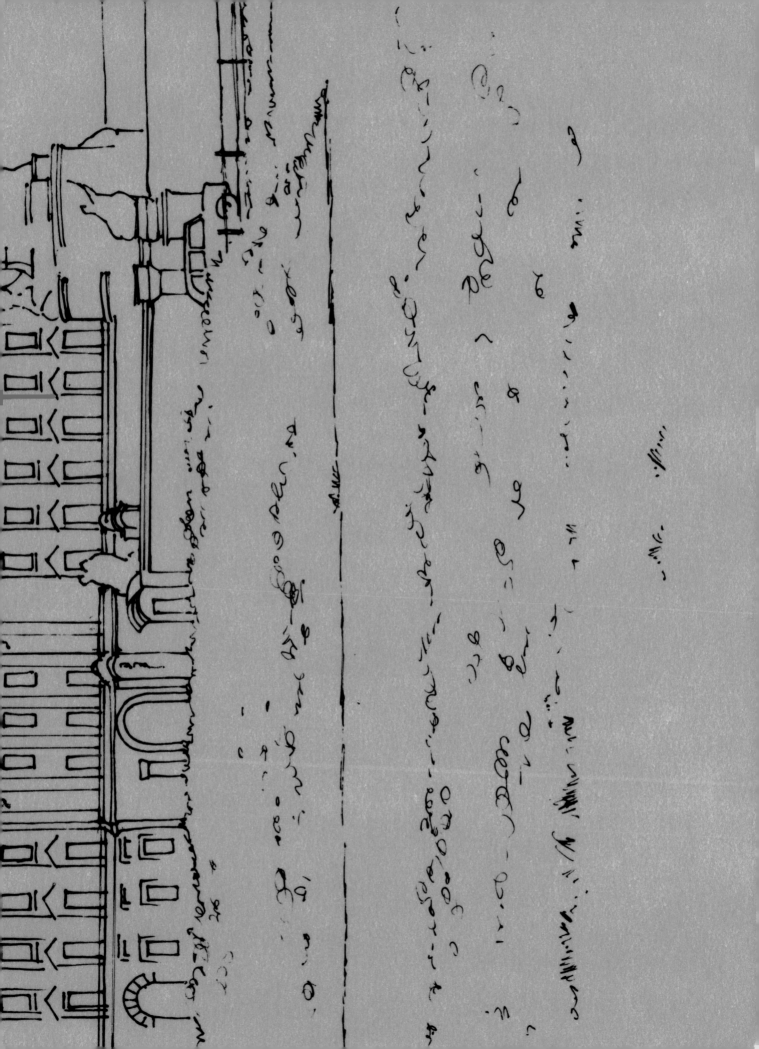

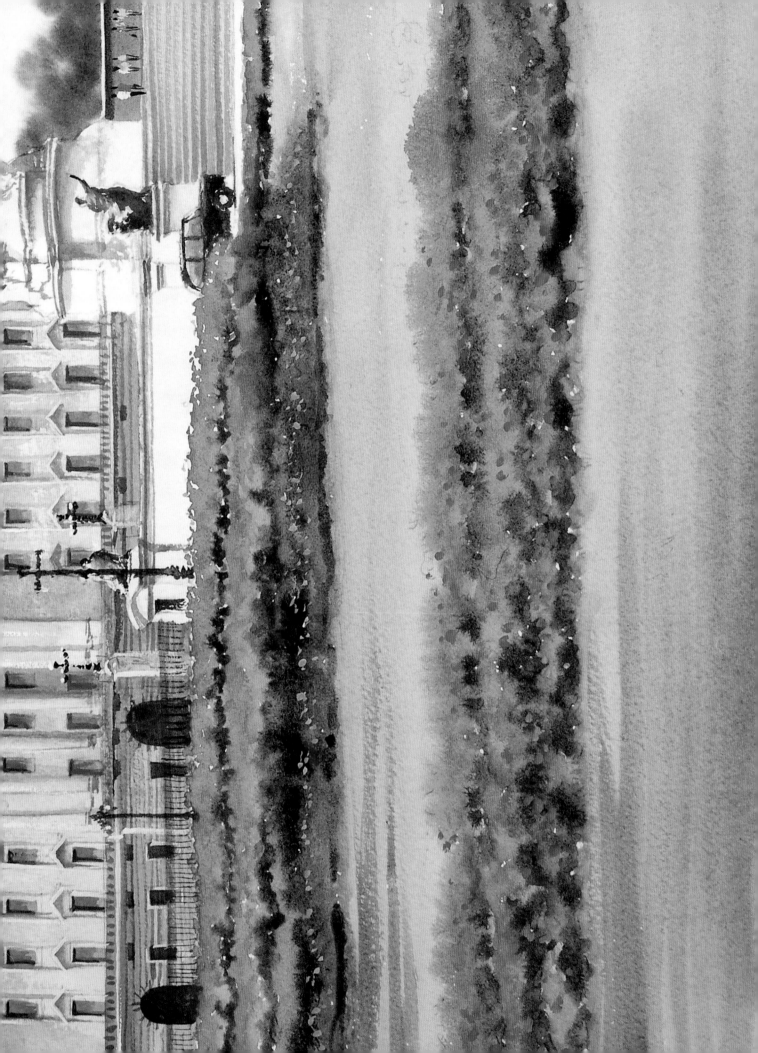

22 Paint the flag post with white gouache and the no. 1 brush, then shade the right-hand side with cerulean and rose madder.

23 Remove the masking fluid from the statue. Make a gold mix from raw sienna and burnt umber and paint it on with the no. 1 brush, leaving white where the light catches it. Mix a rich, dark brown from burnt umber and cobalt blue for the darker parts.

24 Paint a thin wash of cerulean blue with the no. 8 brush over the stone of the monument. When this is dry, model the monument with the no. 1 brush and cerulean, rose madder and light red.

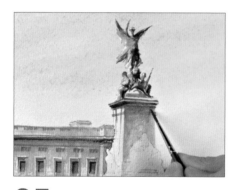

25 Work on the stone monument with the same mix and the no. 4 brush, establishing light and shade.

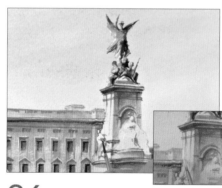

26 Add finer detail to the monument and its Queen Victoria statue with lighter and darker mixes of cerulean, rose madder and light red and the no. 1 brush. Sharpen up the edge with white gouache.

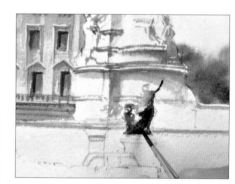

27 Mix burnt sienna and ultramarine to suggest the little bronze statue, just giving an idea of the shapes and softening with clean water. Bring it down to a straight line at the bottom.

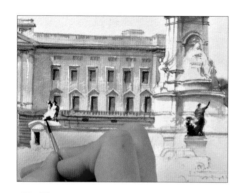

28 Paint the plinth under the bronze statue with cerulean blue and rose madder. Paint the details of the white dais in the same way. Return to the burnt sienna and ultramarine mix for the second bronze statue and the plaque beneath it.

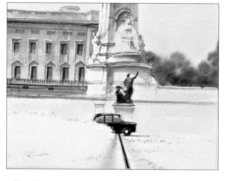

29 Paint the London taxi with ultramarine and burnt sienna, then paint the windows with cerulean blue and rose madder, and drop the same dark mix into this.

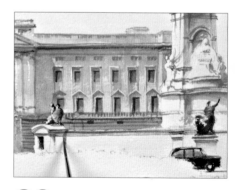

30 Add more detail to the white dais with cerulean blue, rose madder and light red.

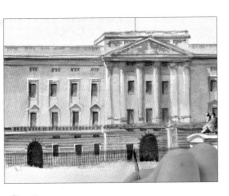

31 Simplify the gold railing tops with a line of raw sienna and burnt sienna, painted with a no. 4 brush, then use the no. 1 brush and burnt sienna and ultramarine to paint the railings with quick vertical lines.

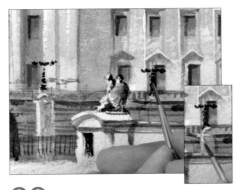

32 Paint the ornate lamps on top of the gateposts with the same mix, just suggesting their shapes. Paint the right-hand gatepost by washing away colour with a damp brush. Blot it with kitchen paper then highlight it with white gouache and raw sienna.

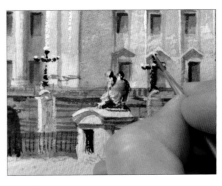

33 Highlight the lamps with the same gouache and raw sienna mix.

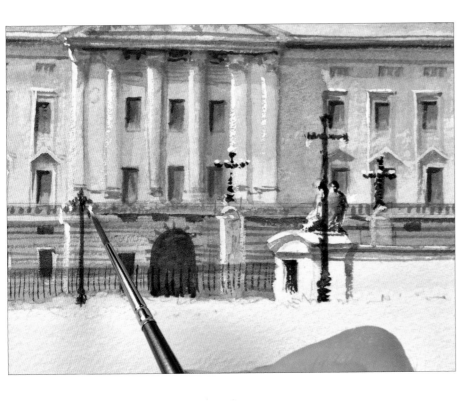

34 Mix ultramarine and aureolin to paint the lamp post in front of the statues, then paint the other one further away. Suggest the lamp glass with white gouache.

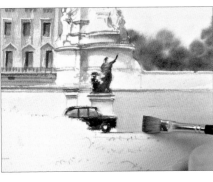

35 Paint the area of the steps with the 10mm (³/₈in) flat brush and Naples yellow and rose madder. While this is wet, drop in raw sienna and burnt sienna to warm it. Allow to dry.

36 Change to the no. 1 brush and paint quick strokes across for the steps with cerulean blue, rose madder and light red.

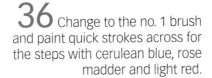

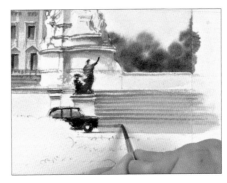

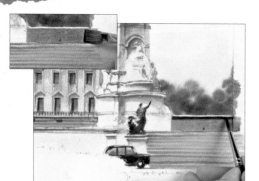

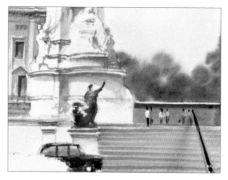

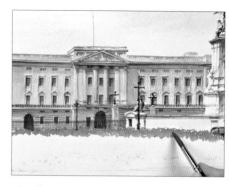

37 Paint the wall behind the steps with the 10mm (⅜in) flat brush and a mix of burnt umber and raw sienna, then paint a darker line near the top with burnt sienna and ultramarine and the no. 4 brush. Leave a white highlight at the top.

38 Suggest people with daubs of colour: white gouache; cadmium red with white gouache; cerulean blue with white gouache; and aureolin, cobalt blue and white gouache. Paint heads and legs with burnt sienna and ultramarine.

39 Mix cadmium red with a little aureolin to make a more orangey red and use the no. 1 brush to paint the tops of the furthest row of flowers, then change to the no. 8 brush to paint the lower part of the row.

40 While the flowers are still wet, paint a row of bright green just below them with aureolin and a touch of cobalt blue, then, still working wet into wet, paint a row of dark green below this, mixed from ultramarine and aureolin.

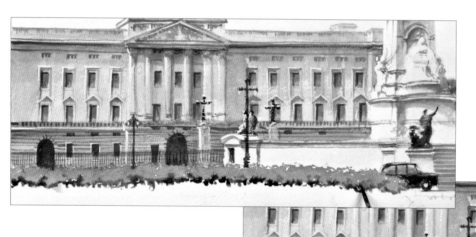

41 Leave a little white paper between the green and the next row, then continue with a second row of red flowers, then bright green, then dark green, then more red, working fast with the no. 8 brush so that the colours merge into each other.

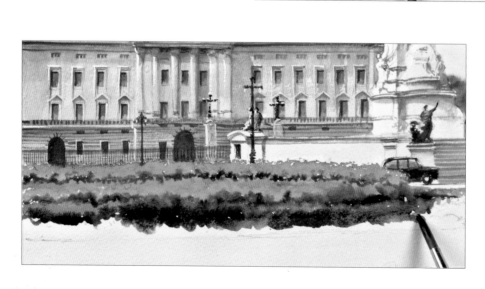

42 Add a row of dark green, then a purple row mixed from ultramarine and rose madder.